St Patrick's Day Coloring Book

This St Patricks Coloring book belongs to:

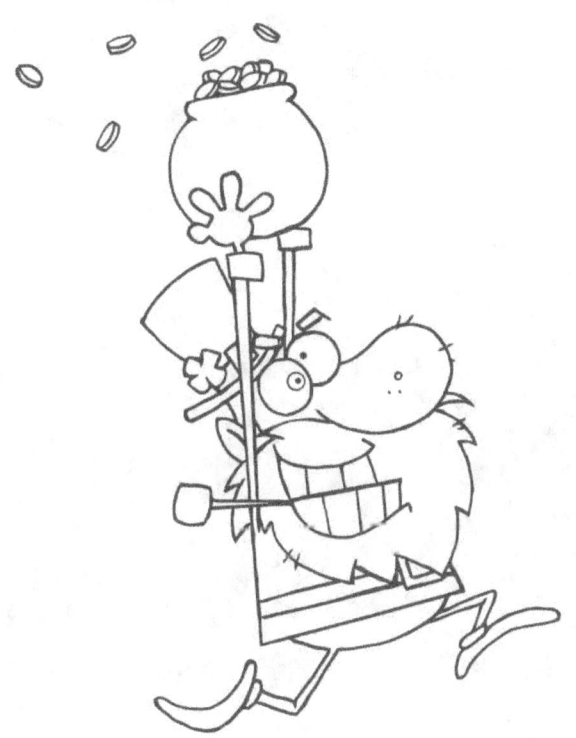

Copyright © 2019 St.Patricks Activity Books

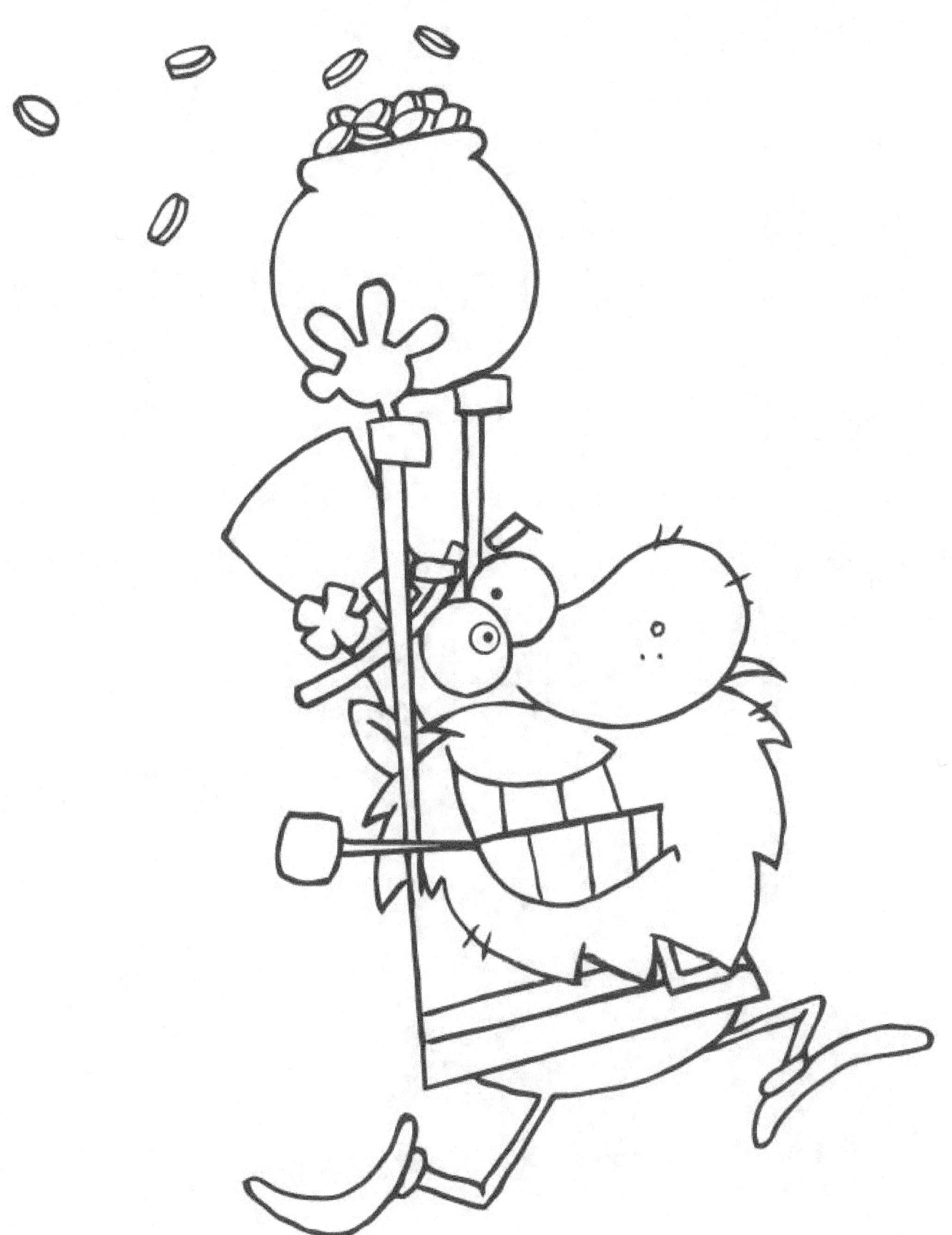

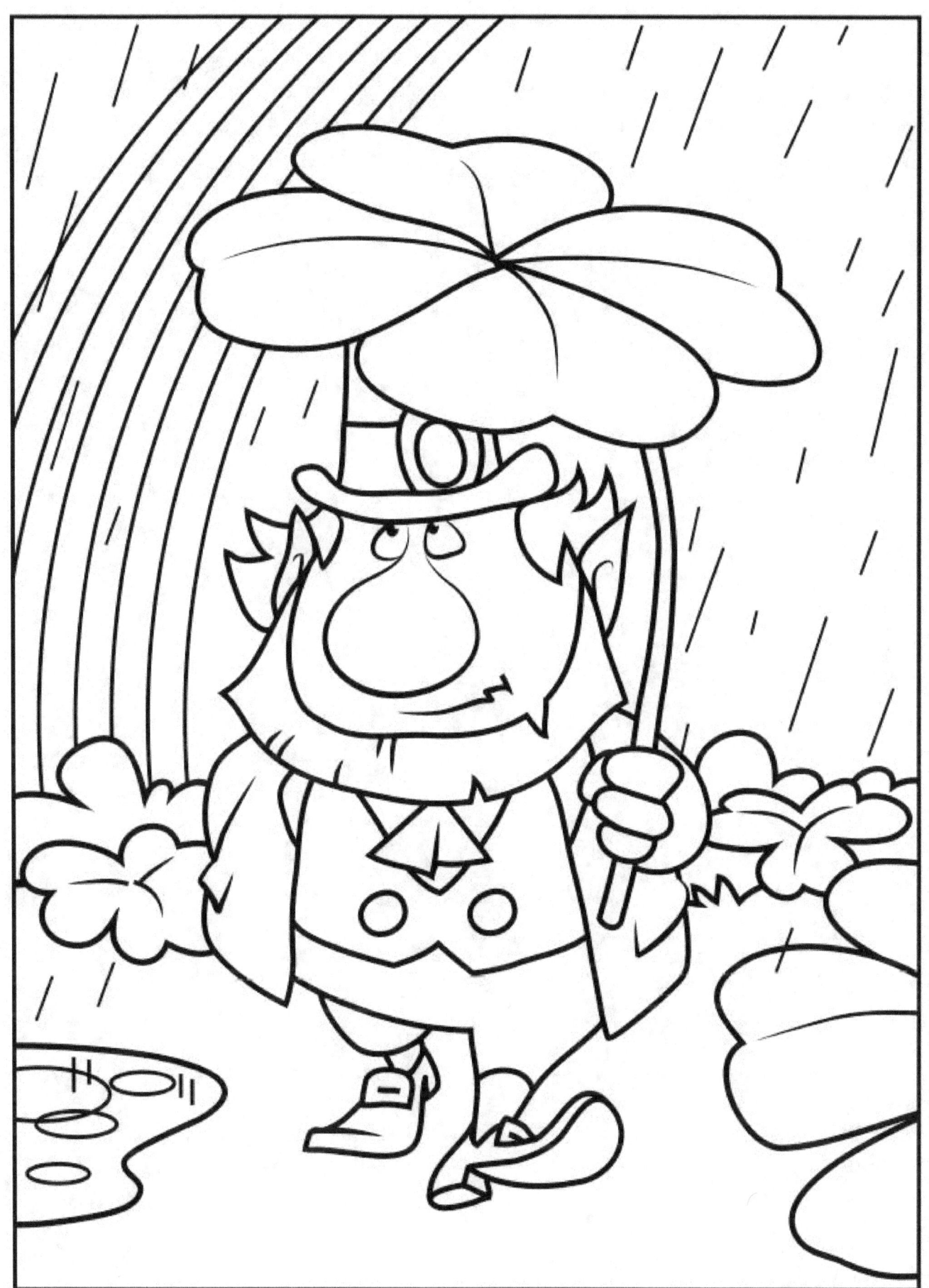

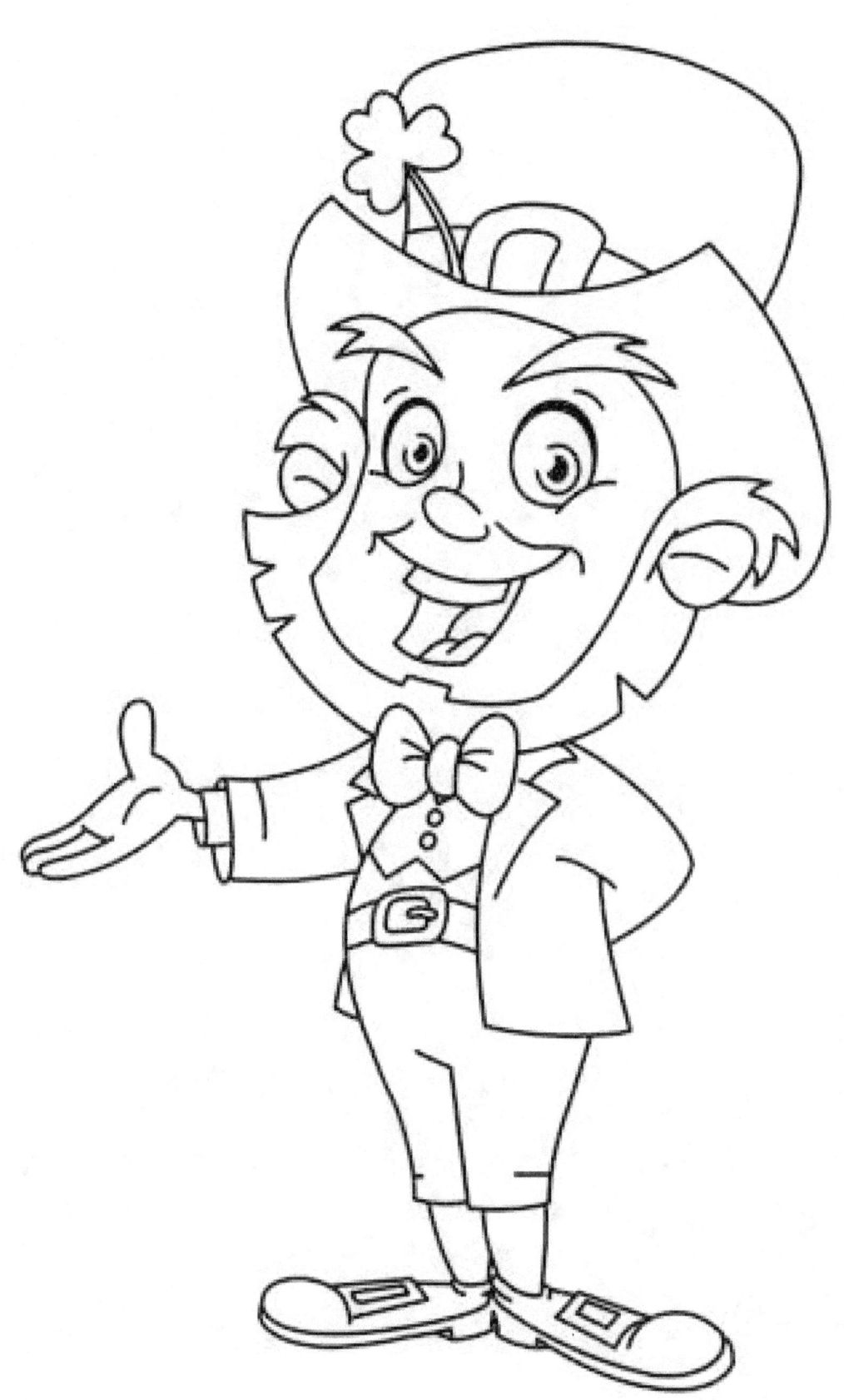

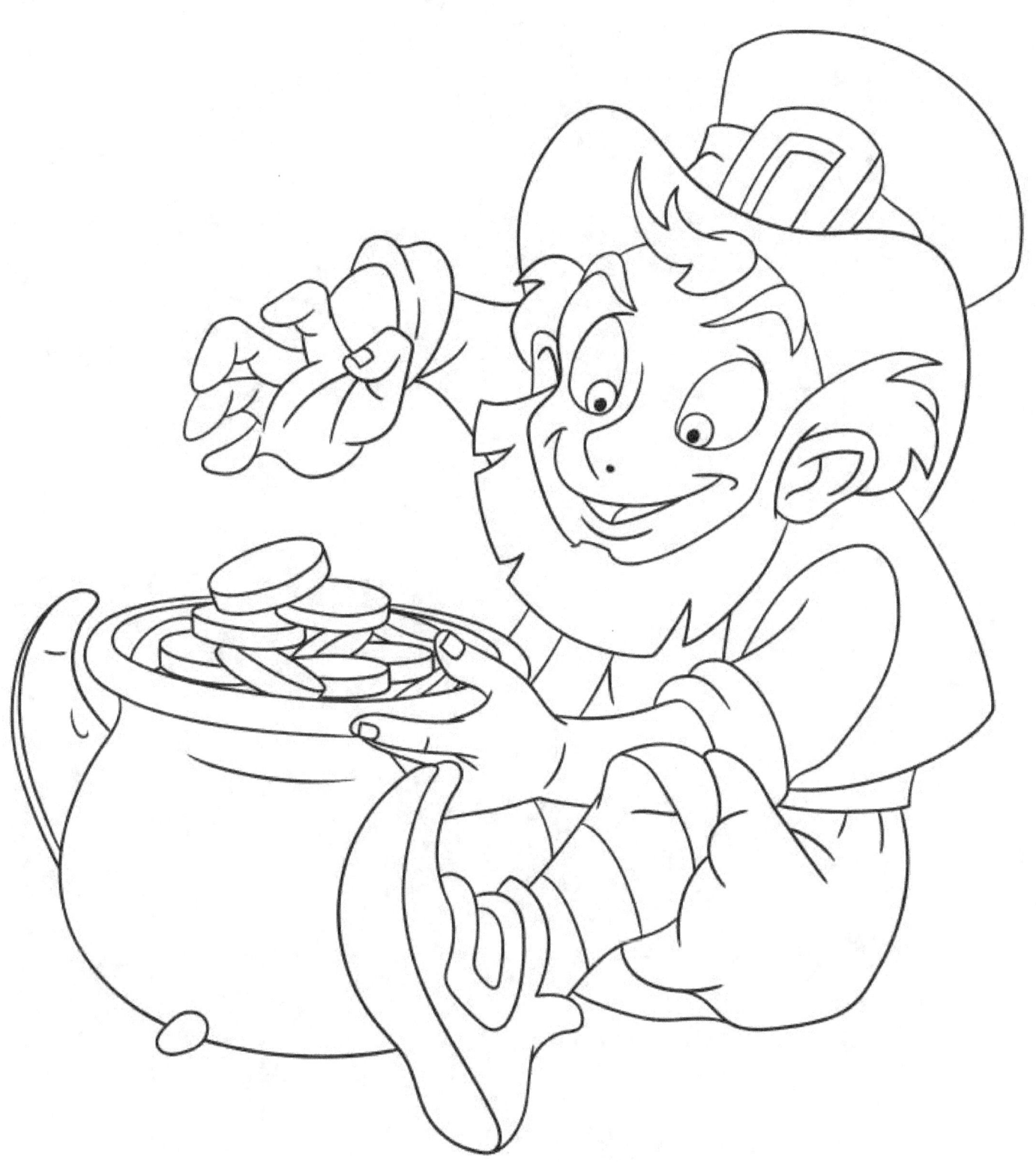

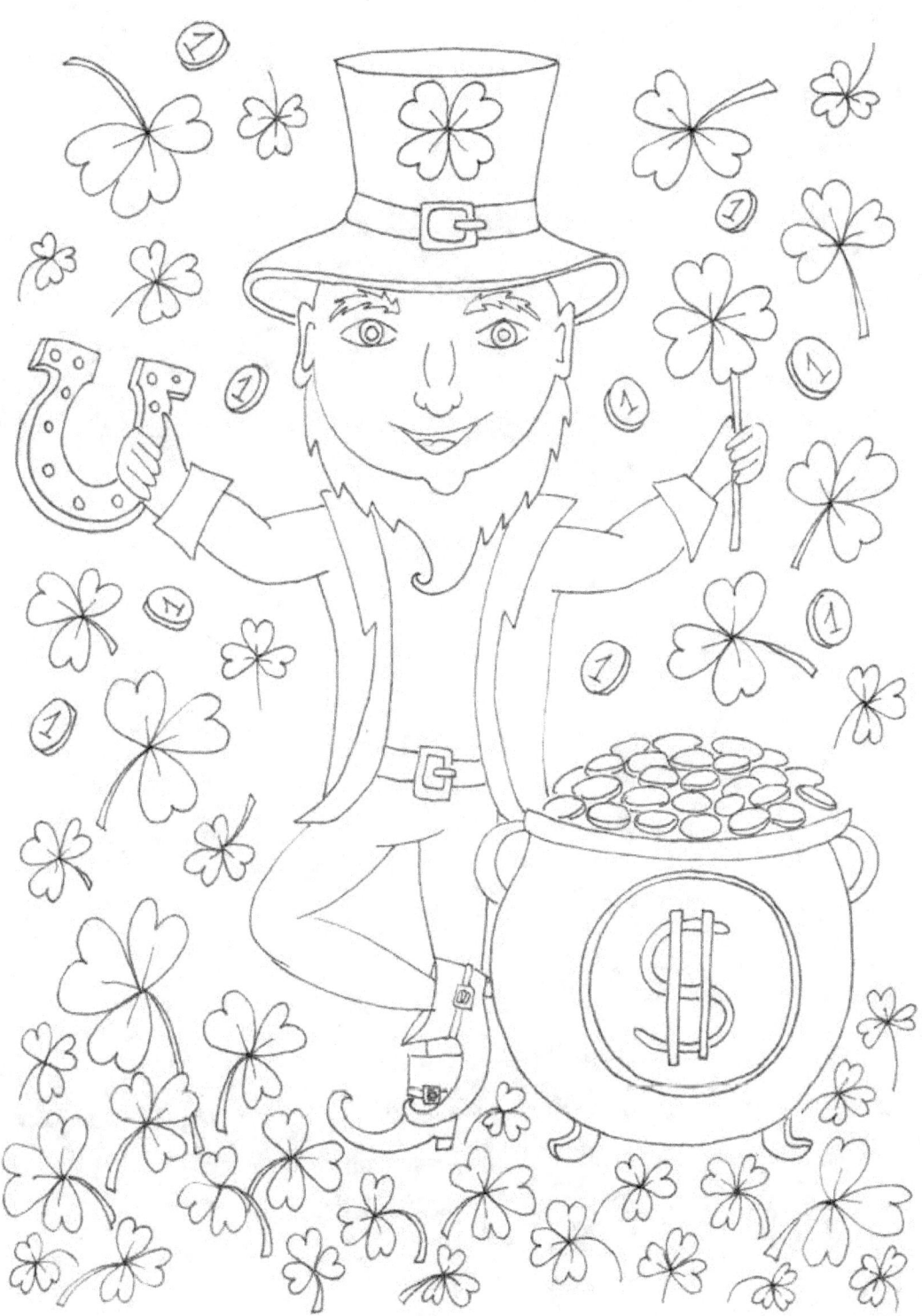

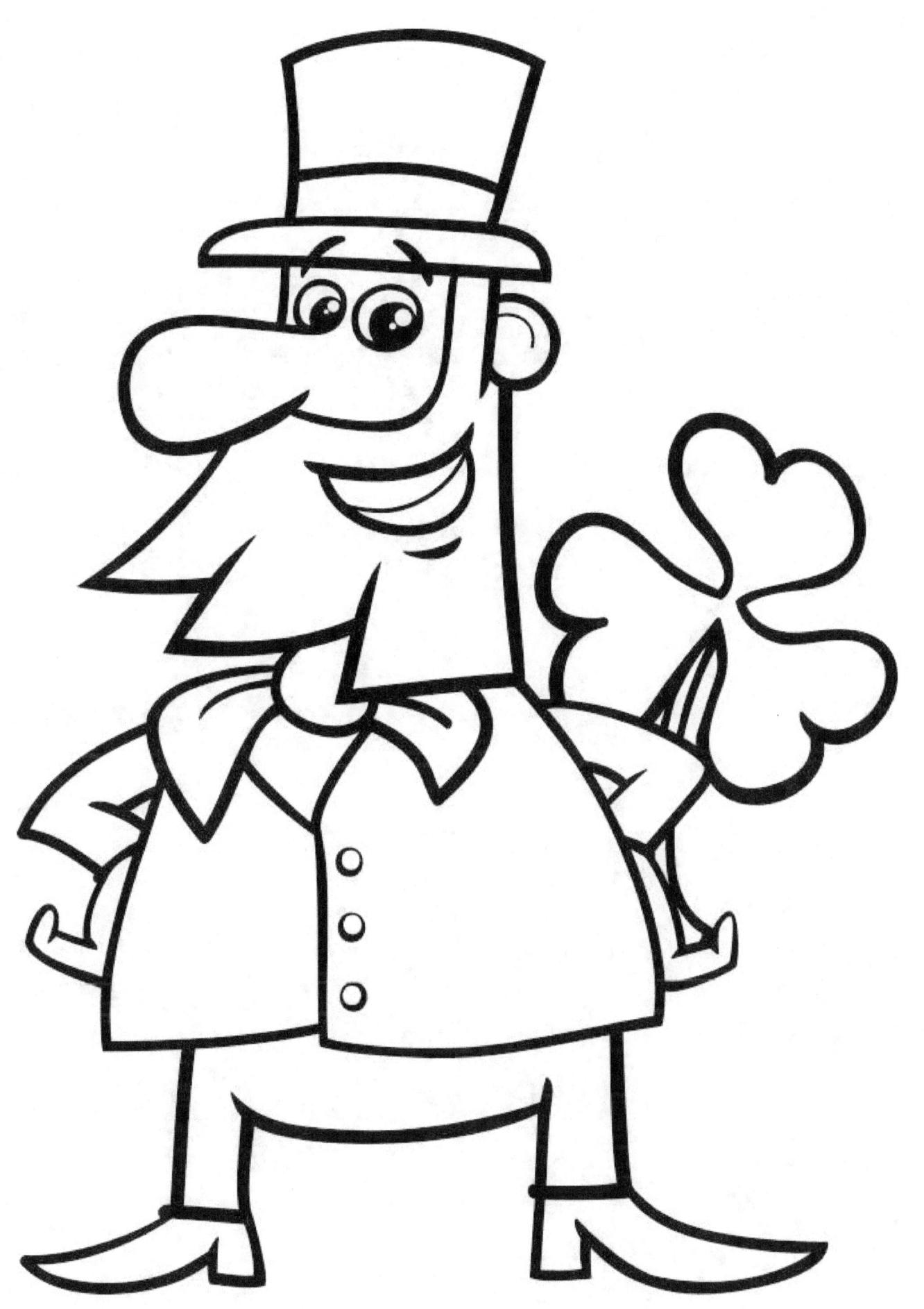

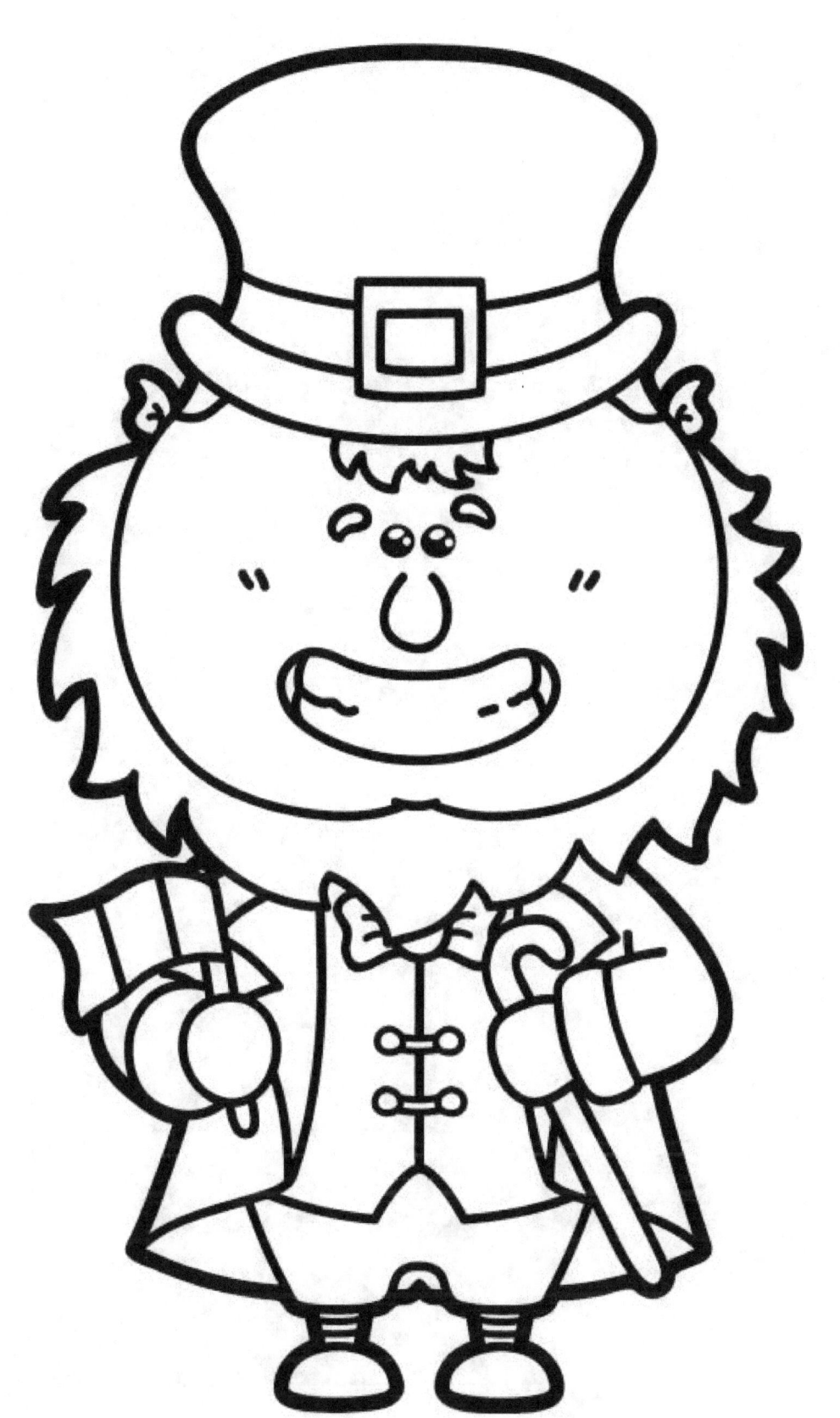

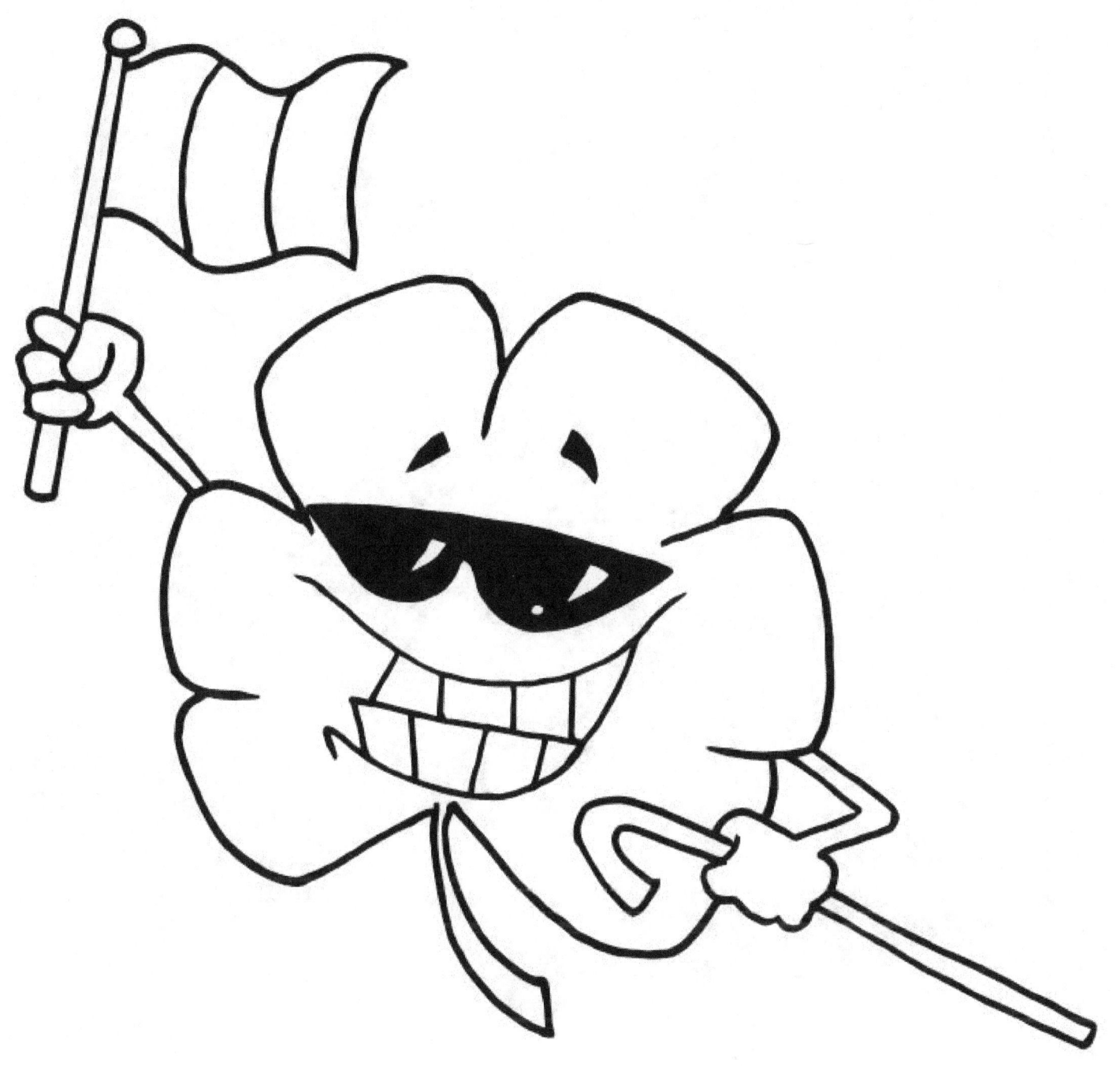

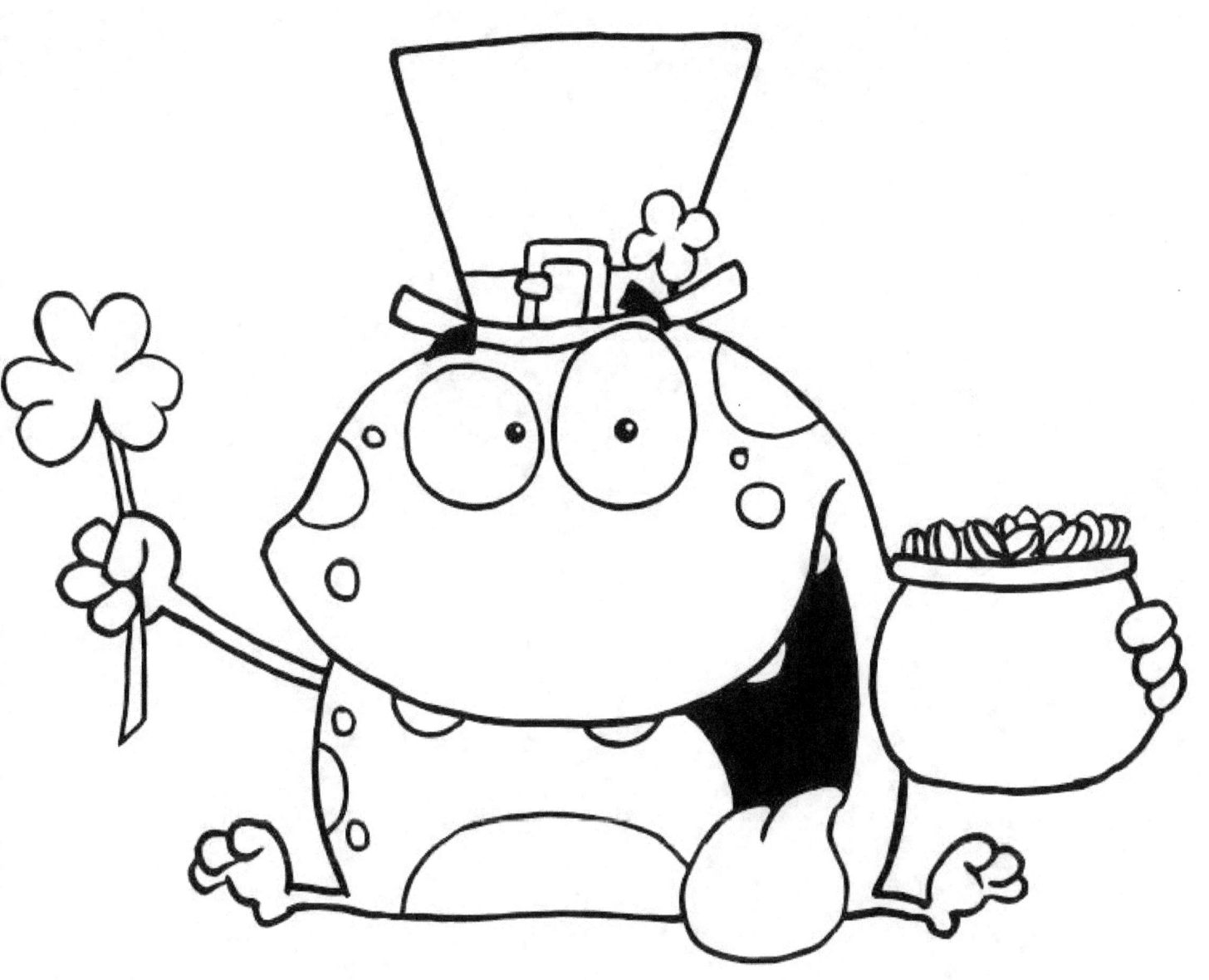

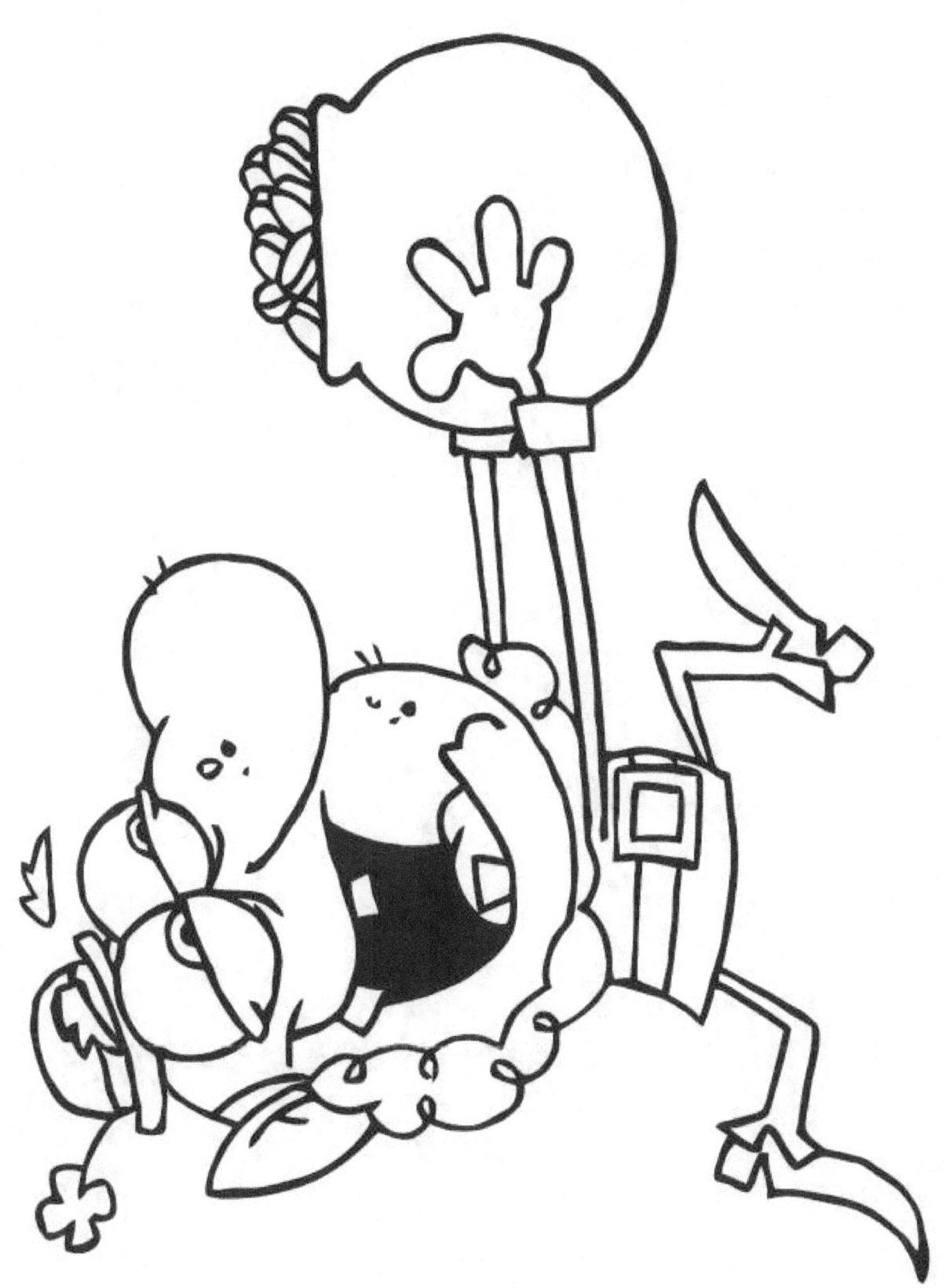

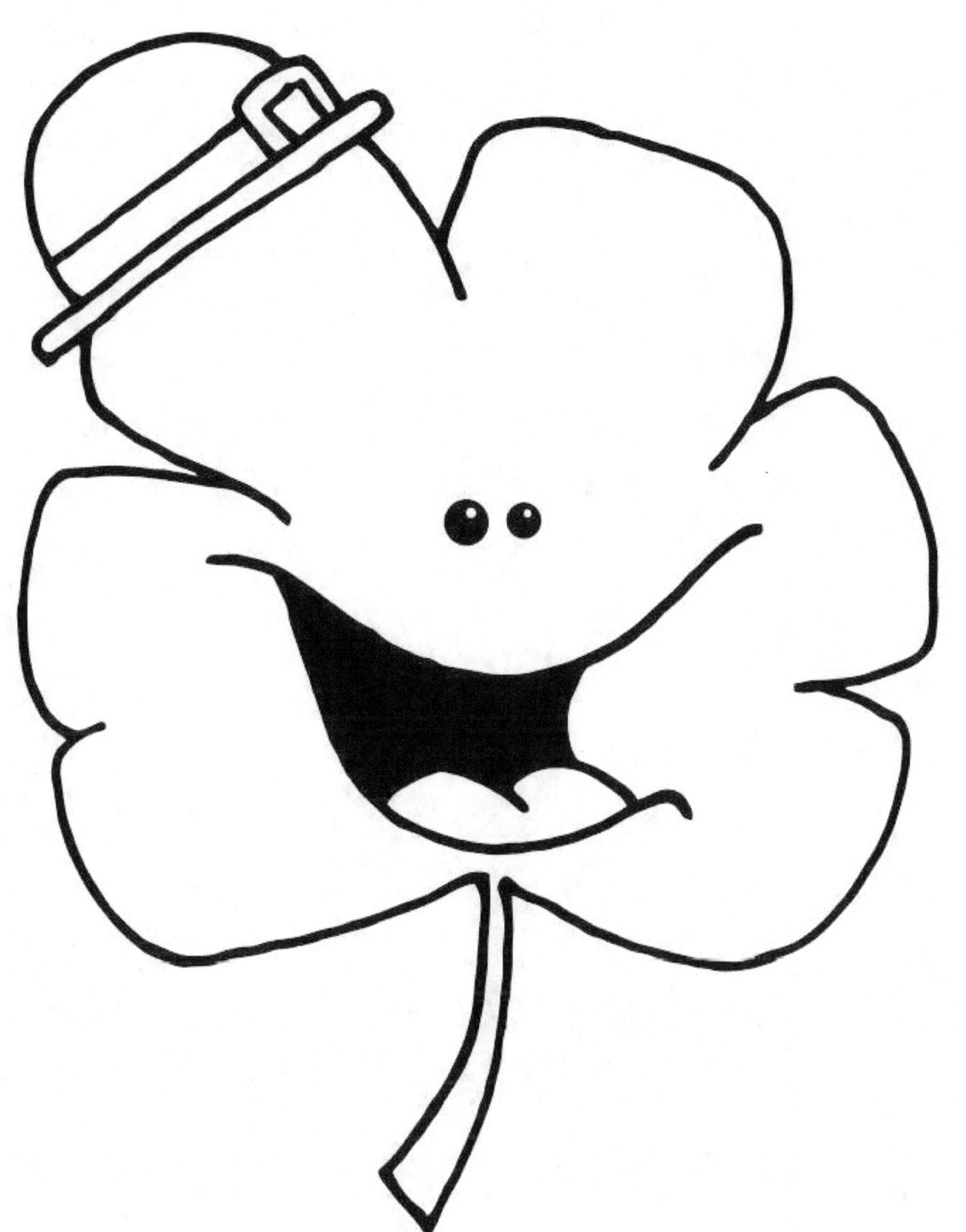

Find 10 differences

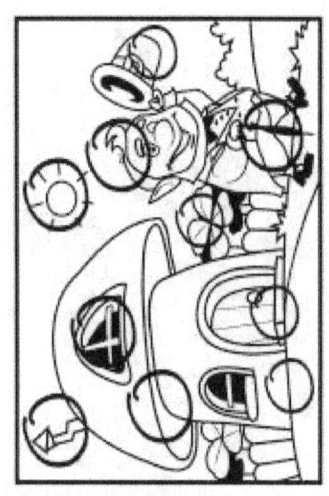

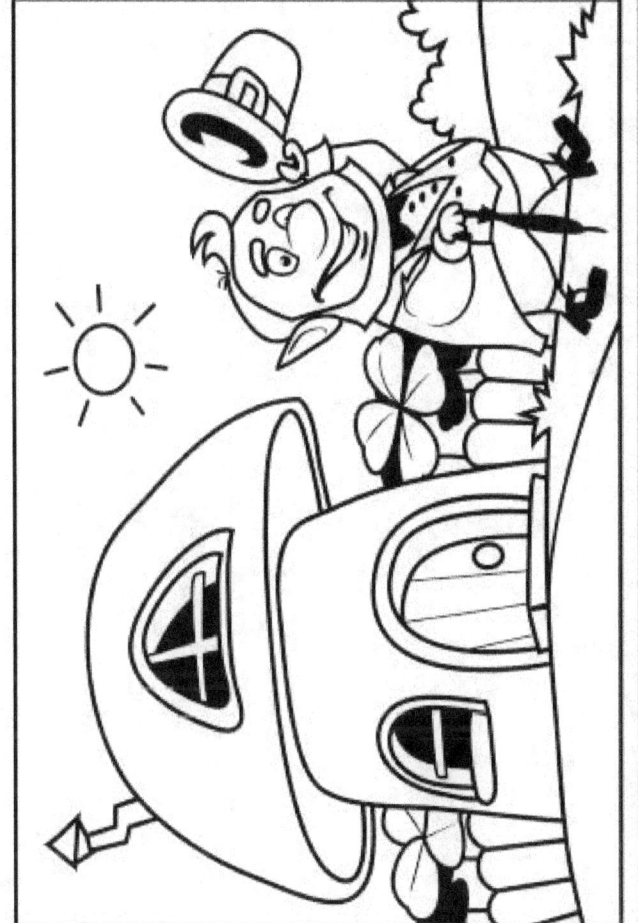
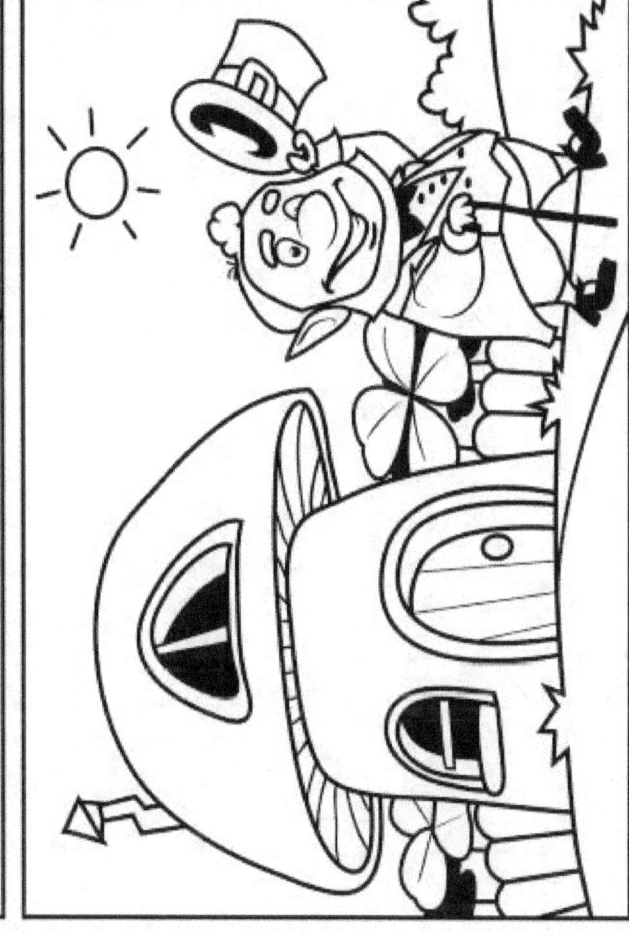

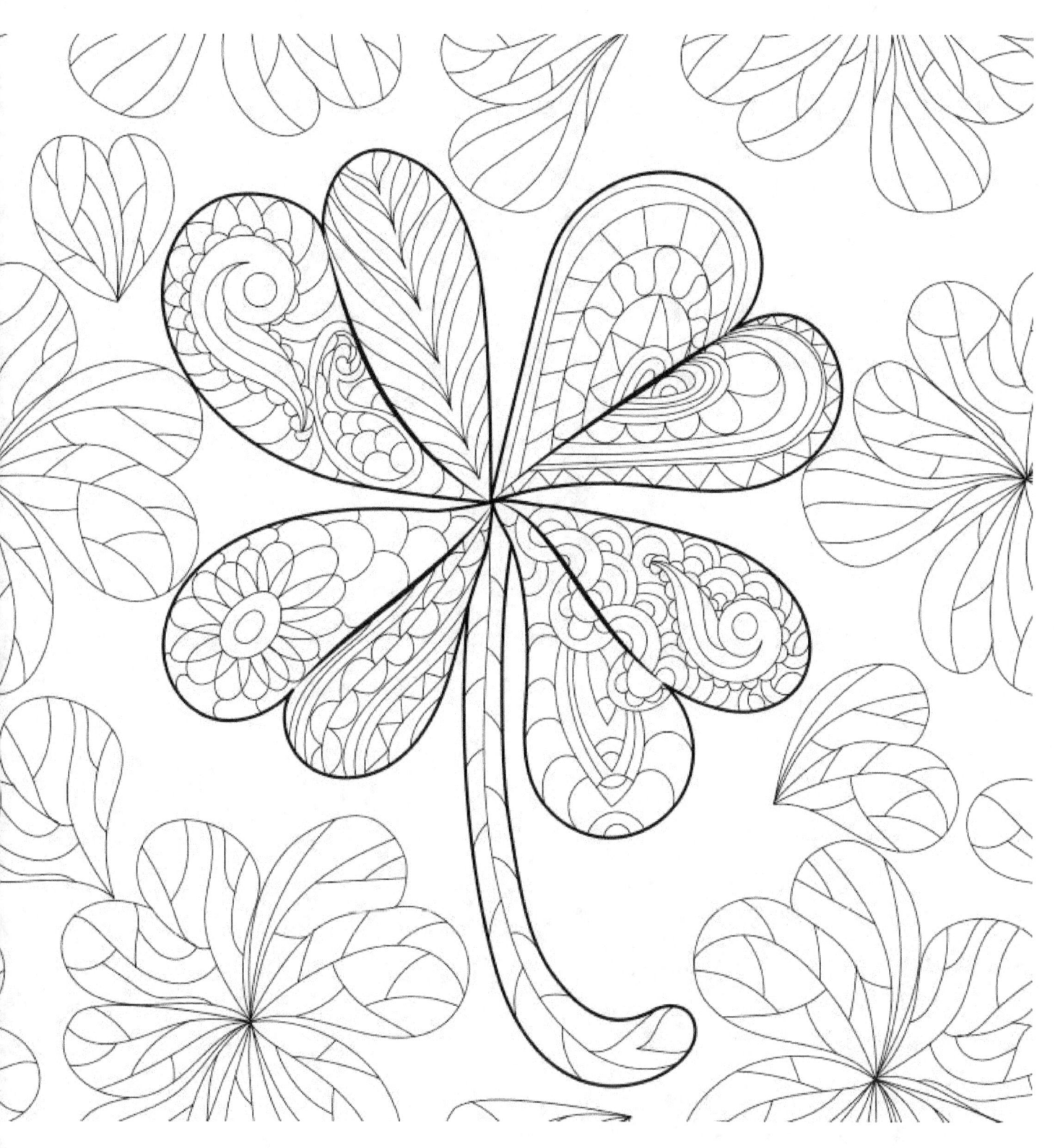

Draw a line from dot number 1 to dot number 2, then from dot number 2 to dot number 3, 3 to 4, and so on. Continue to join the dots until you have connected all the numbered dots. Then, color the picture!

ANSWER: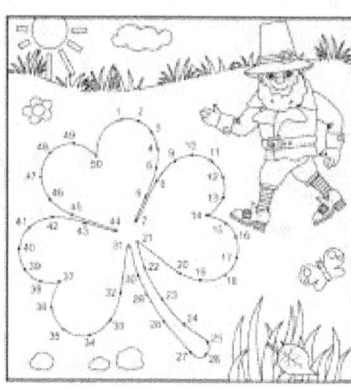

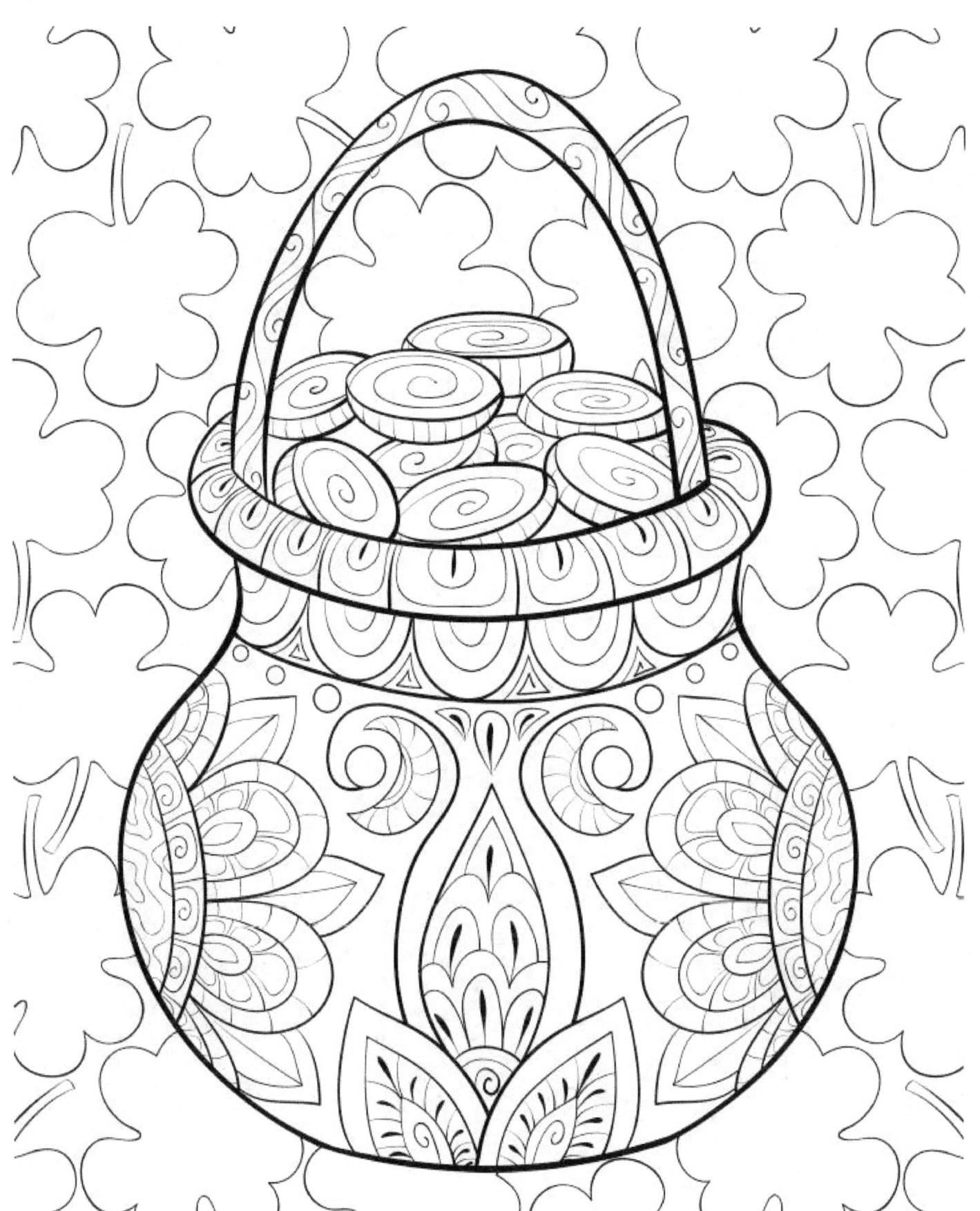

www.ingramcontent.com/pod-product-compliance
Lightning Source LLC
Chambersburg PA
CBHW081624220526
45468CB00010B/3014